THE APERTURE HISTORY OF PHOTOGRAPHY SERIES

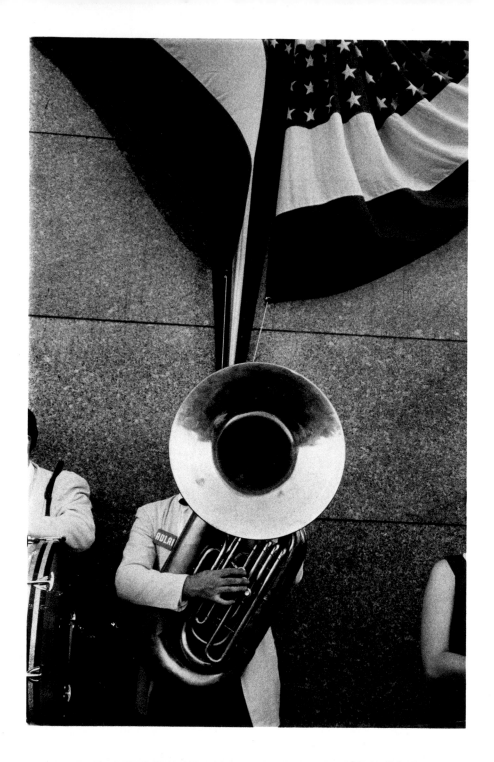

Robert Frank

APERTURE

778

The History of Photography Series is produced by Aperture, Inc., under the artistic direction of Robert Delpire. *Robert Frank* is the second book in the series.

Aperture, Inc., publishes periodicals, portfolios and books to communicate with serious photographers and creative people everywhere. A complete catalogue will be mailed upon request. Address: Elm Street, Millerton, New York 12546.

Library of Congress Catalogue Card No. 76-22001

ISBN: 0-89381-002-9

Manufactured in the United States of America.

There are photographs here that haunt me, as if I've been inside them before; photographs that come forward like incantations, suddenly awakened mysteries full of illumined silence. A moonlit night in New Mexico, a long, flat blacktop road, its presence full in the foreground, then receding into the dim glow of the horizon while a car emerges over a rise, just coming on and yet hanging suspended in the middle of all that endless American space . . . Images from the back roads of the culture, the sad-eyed margins where the process of life is most exposed: skids, drifters, children, housewives, hanging out in backyards, standing in front of jukeboxes, watching over a shrouded body on U.S. 66, great sad stillnesses in the middle of unknown voyages, anonymous icons, yesterday's newspapers, a Texaco sign in Butte, Montana . . . The vision inhabits whatever is most empty, magic gaps, the stuff bones are made out of, seen somewhere from beyond the eye sockets. No one performs, no one arranges an object or turns a profile. Death is here, and celebration. Loneliness and hope, decay and poetry, grief and survival, and those rare moments when a man happens on his own essence. Lives frozen and illuminated and transcended within their own routines . . . Words happen, signs along the way, crossed-out names on old post cards, forgotten gravestones, . . . A

life recorded, confronted, endured: Mary, Pablo, Andrea. Kids, friends, a wife, separations, changes. Everyone, everything, lost, discovered, celebrated, witnessed . . . The unique tracks of a personal life, a litany of fragments, form that obeys nothing but its own intuitions, a shaggy dog story, an empty hotel room in Gallup, New Mexico, a shelter for lost souls, frayed snapshots of old times . . . Here's what he sees. Here's where the mystery . . . Always the drift is toward more personal exploration, more risk. After half a lifetime, the still camera is replaced by a moving camera. More surprises, loss of control, dirty hands, margins expanded, questioned, destroyed. New York is gone. A family is gone. A way of life is gone. Another way found. What is left is what one starts out with, the first glance, the first object moving through space, the act itself . . . One last photograph years later (a parenthesis to himself): the land and seascape in front of the Nova Scotia home, the last freeze of winter before the season turns. "The ice is breaking up. The water will be warm and blue."

Rudolph Wurlitzer

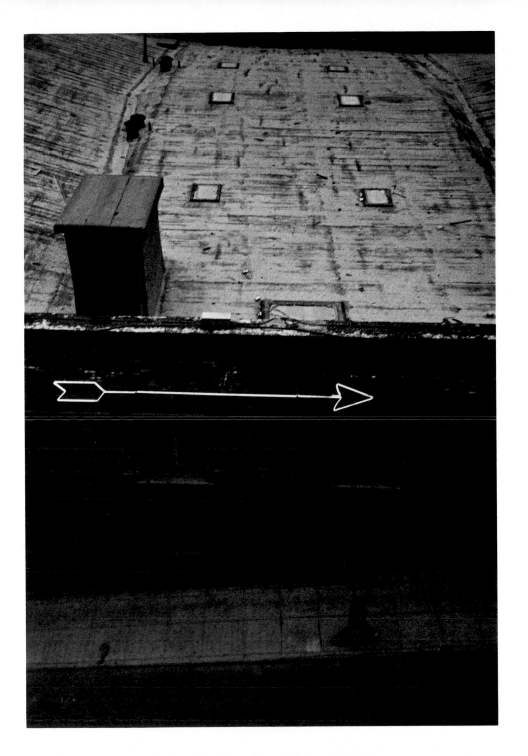

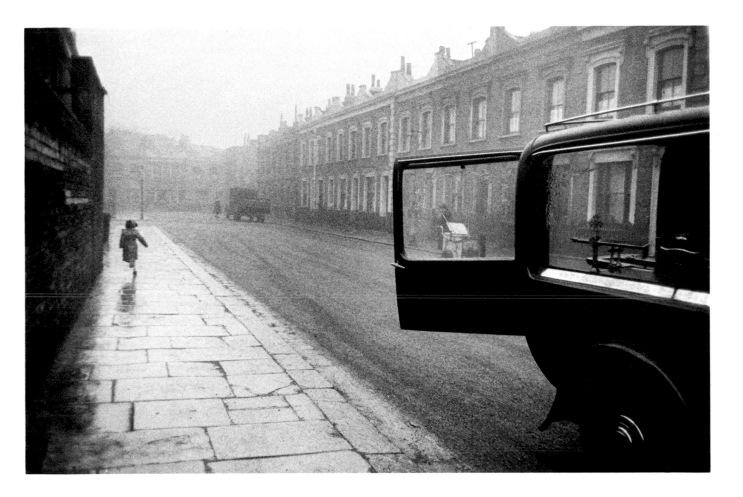

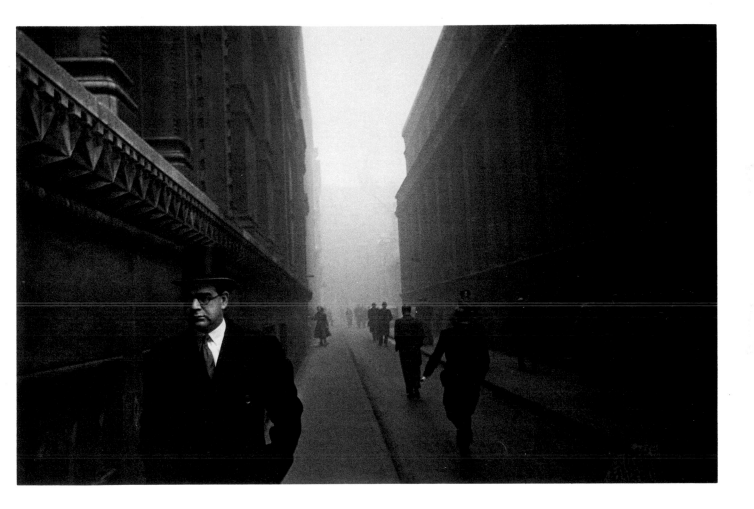

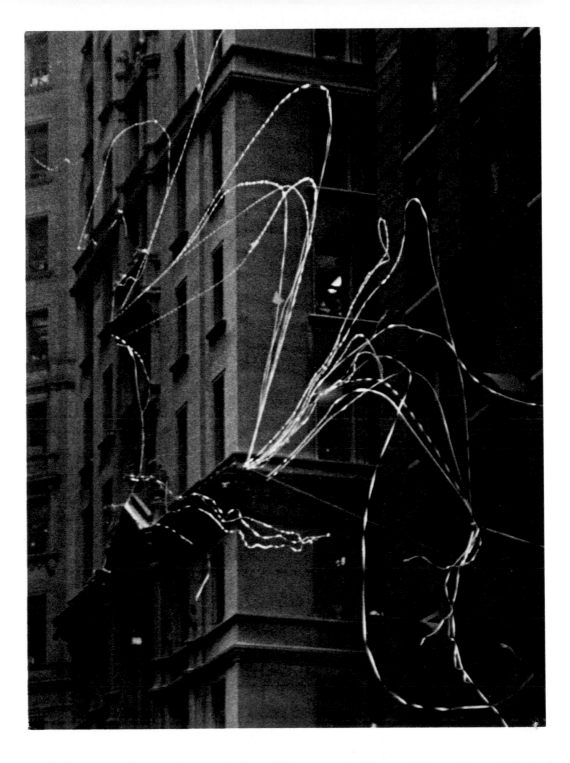

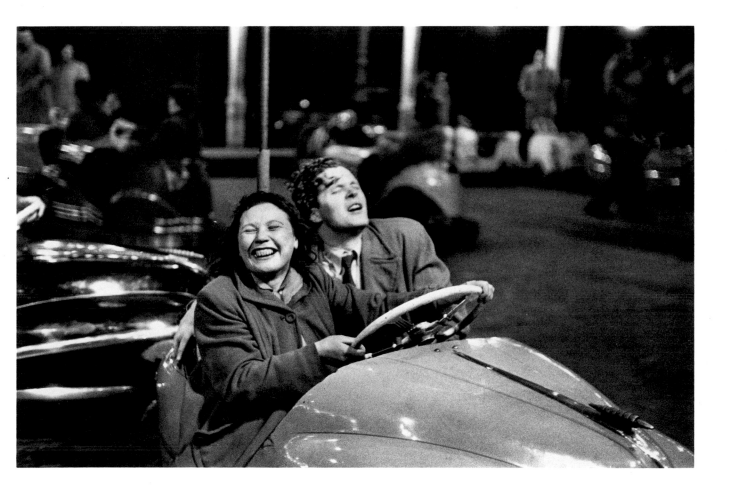

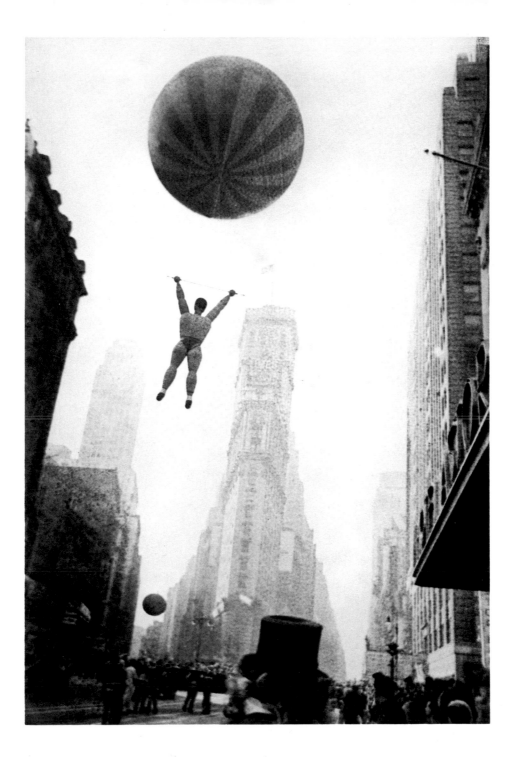

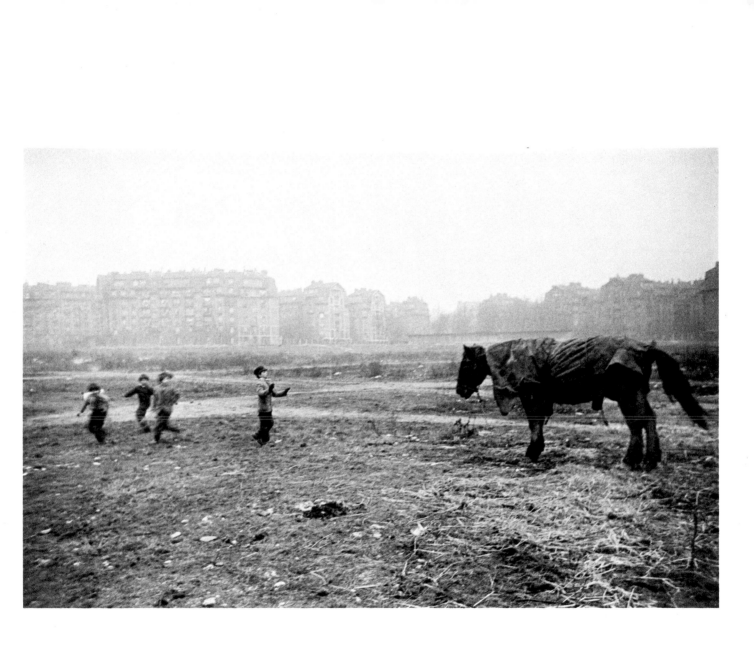

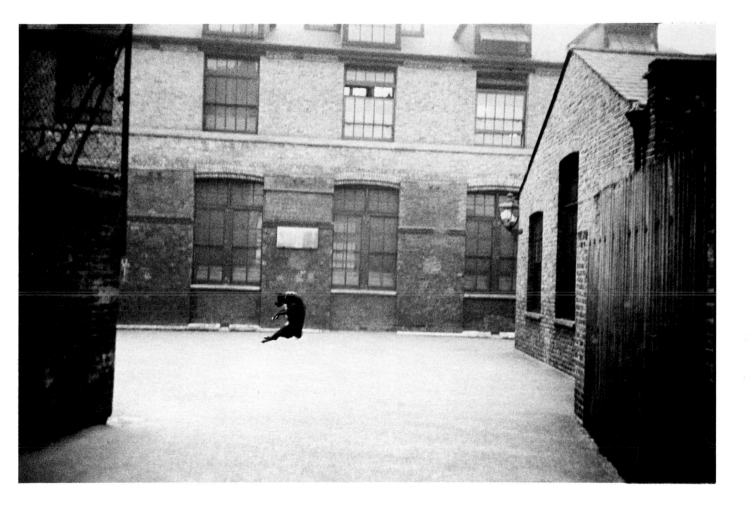

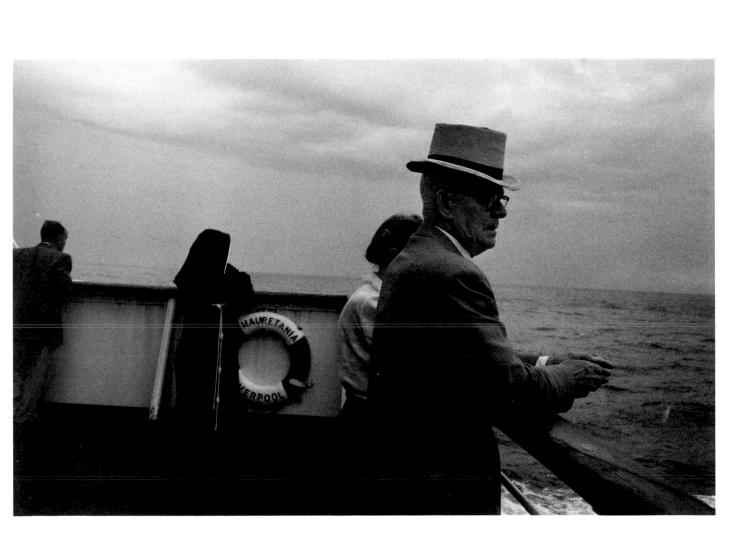

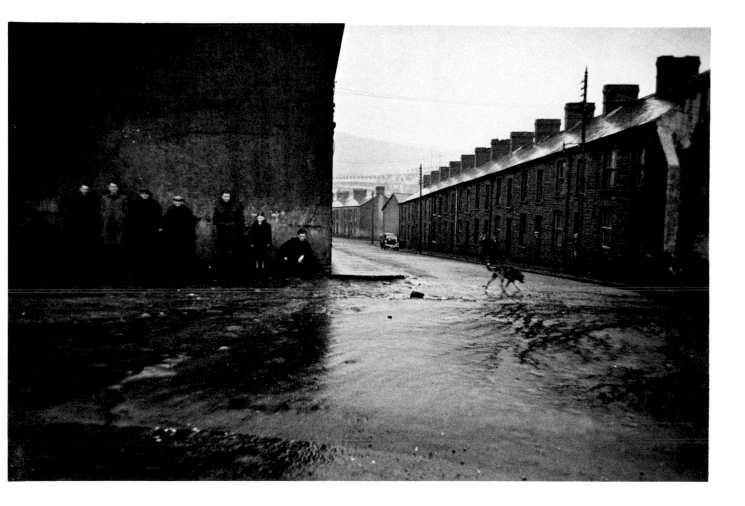

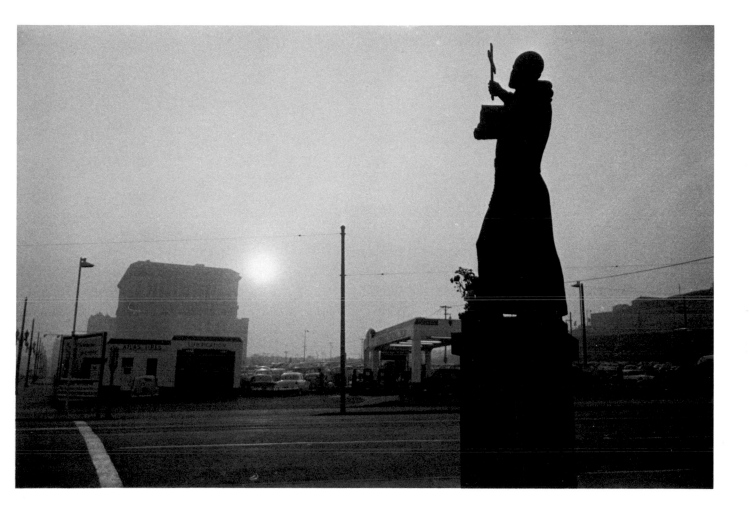

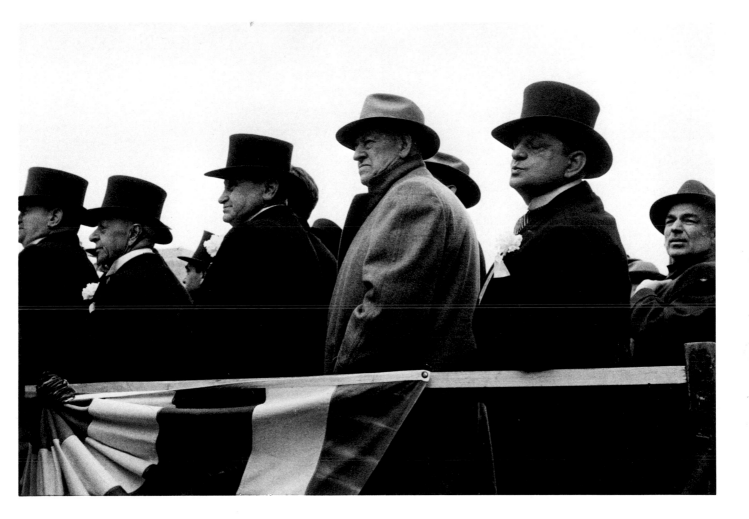

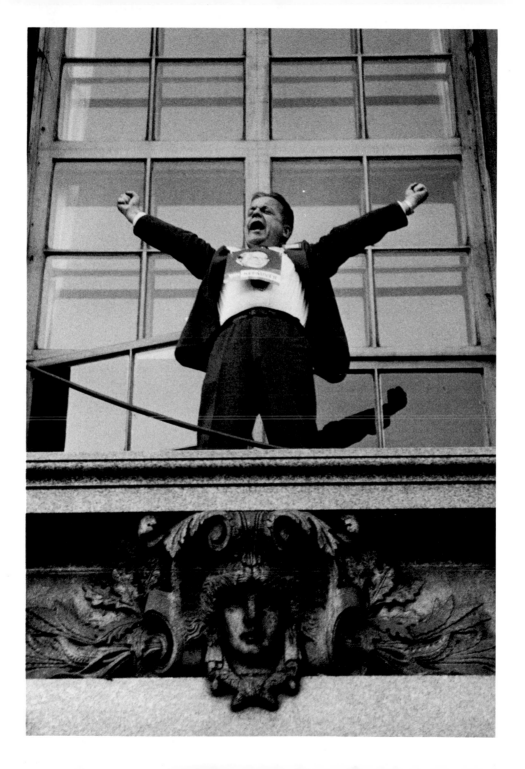

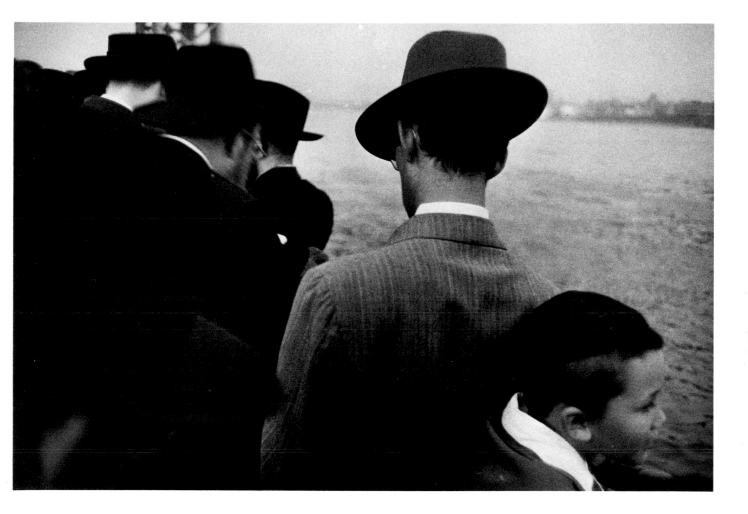

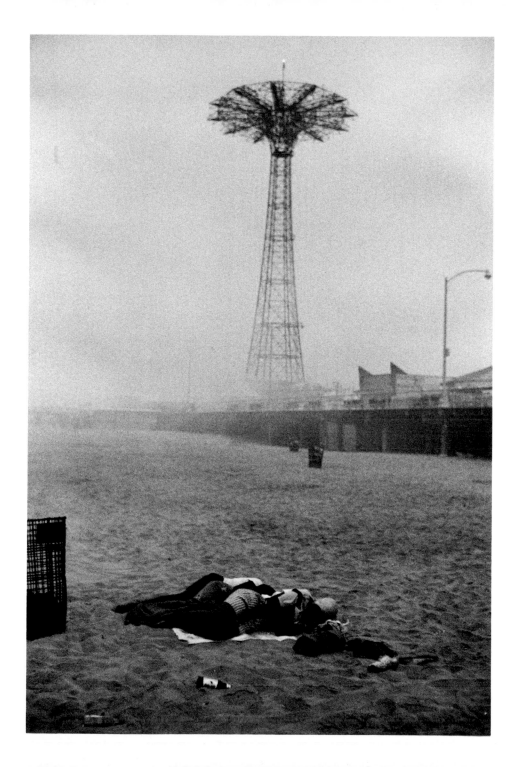

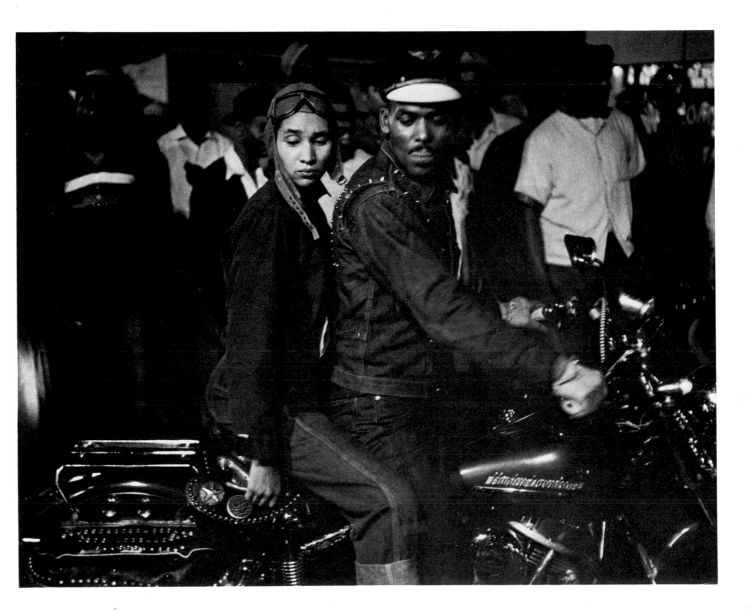

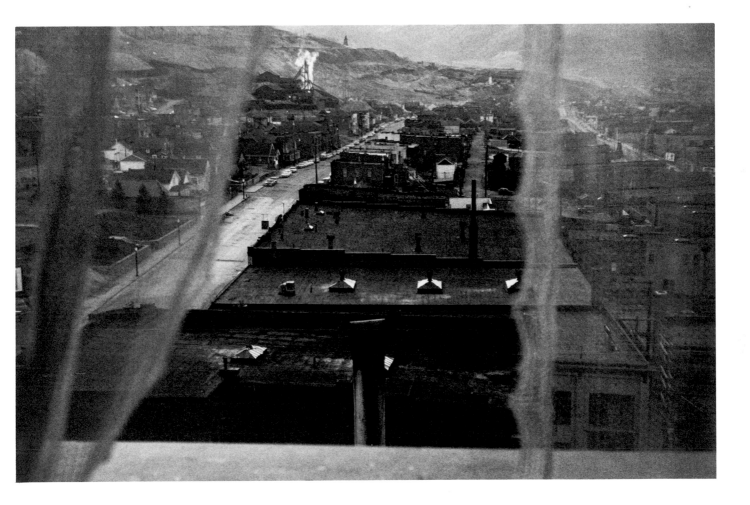

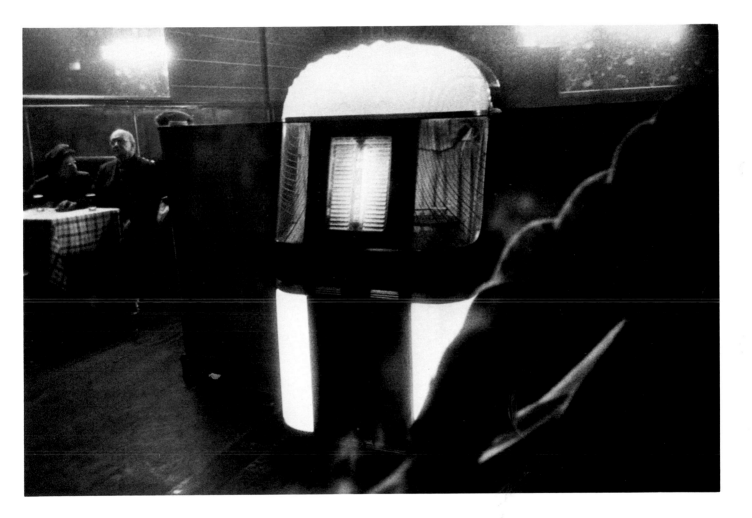

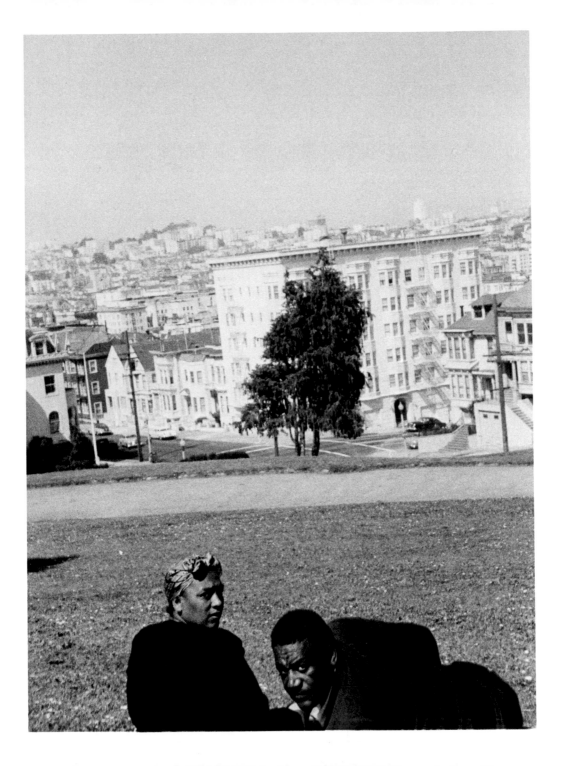

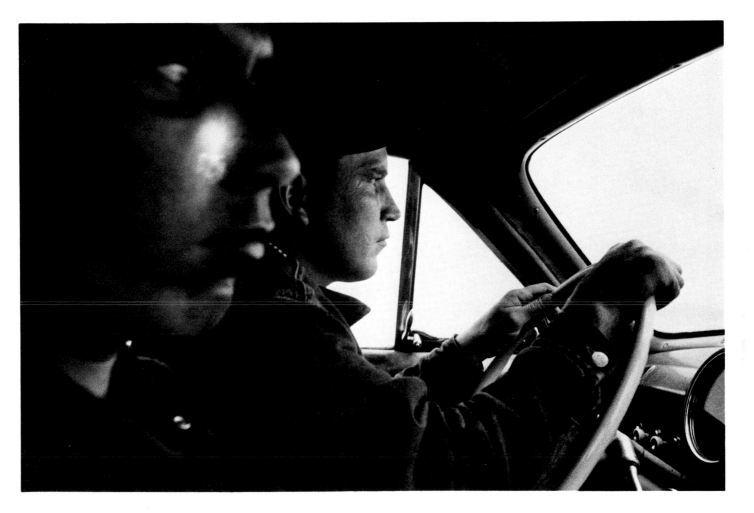

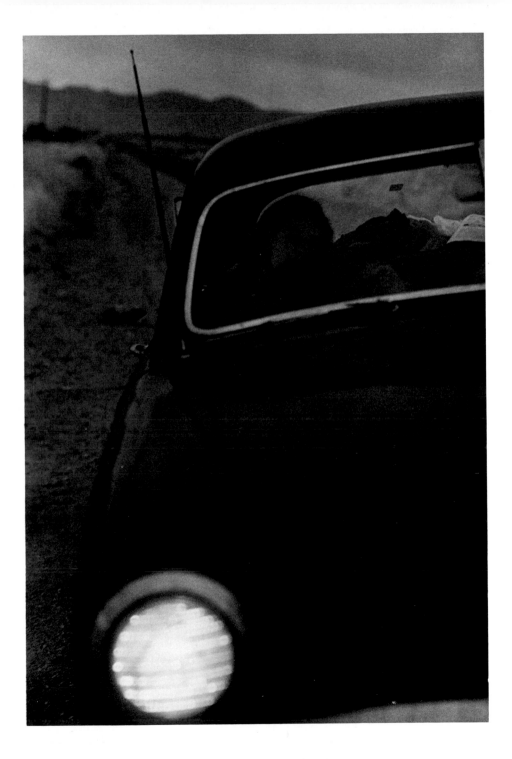

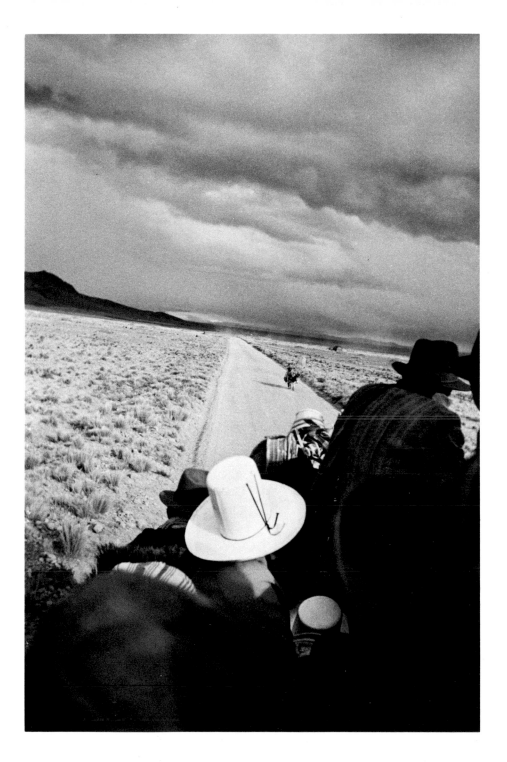

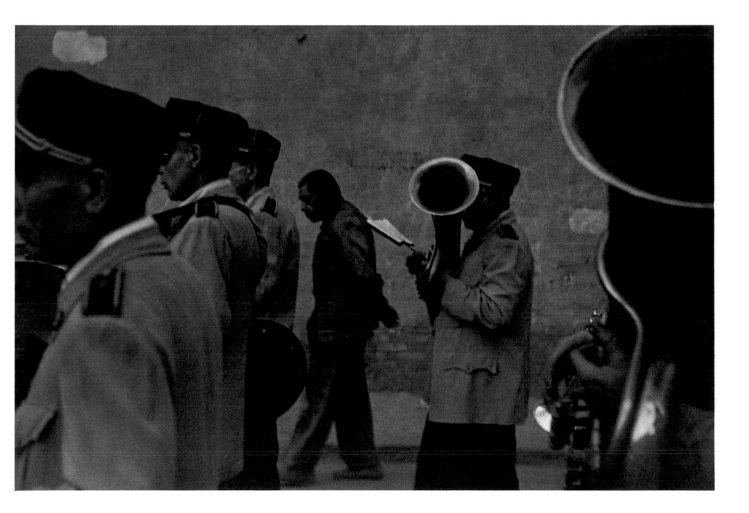

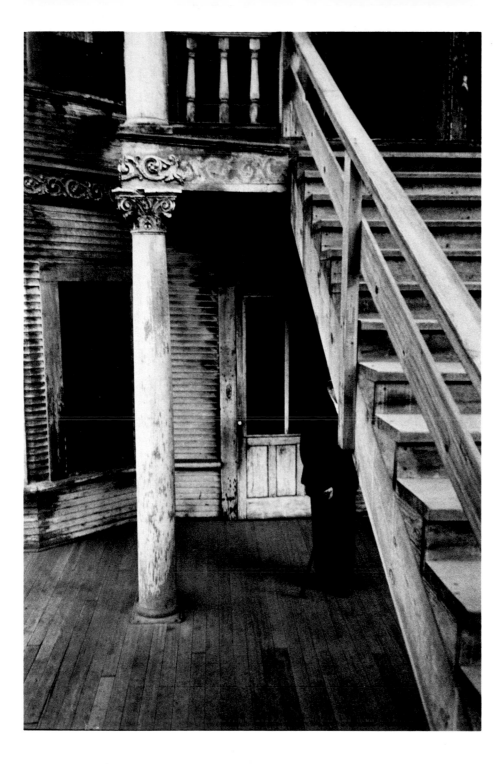

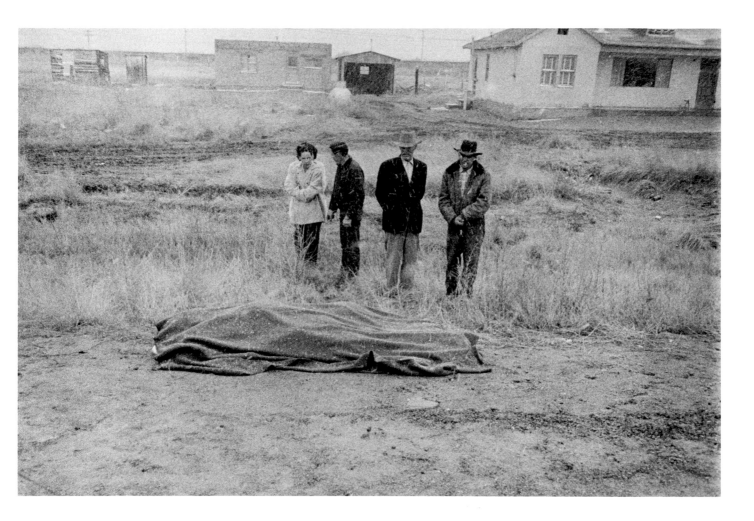

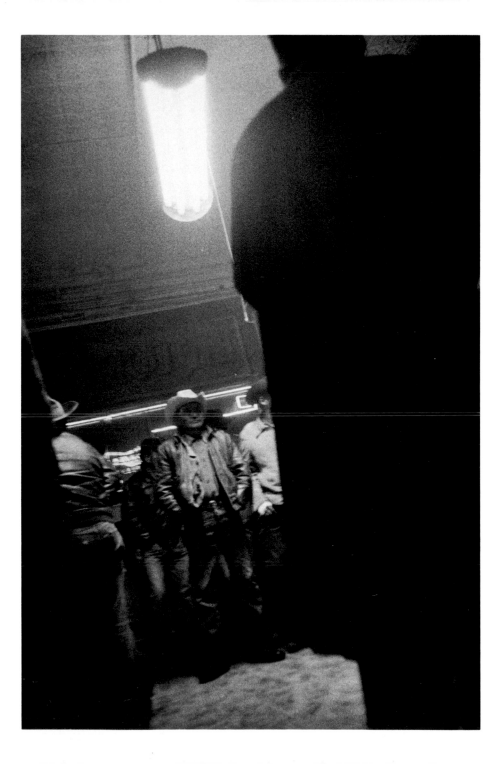

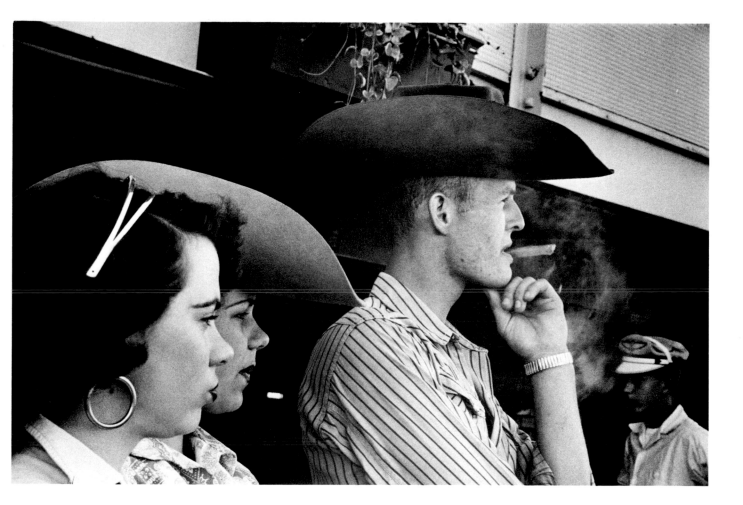

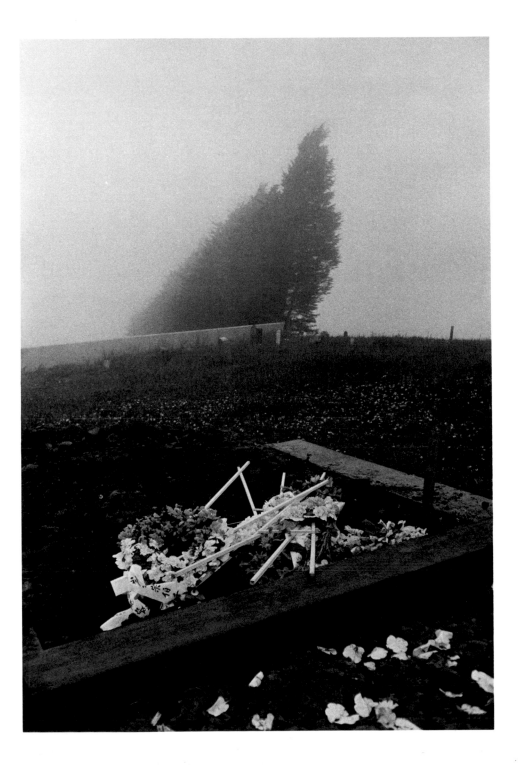

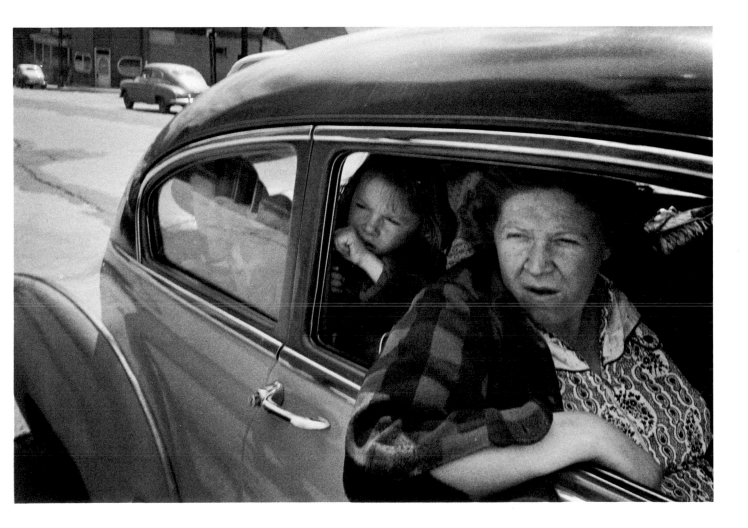

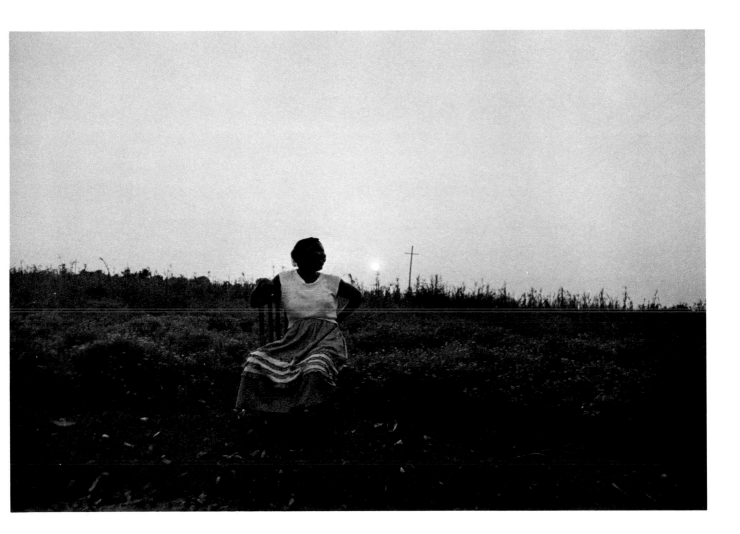

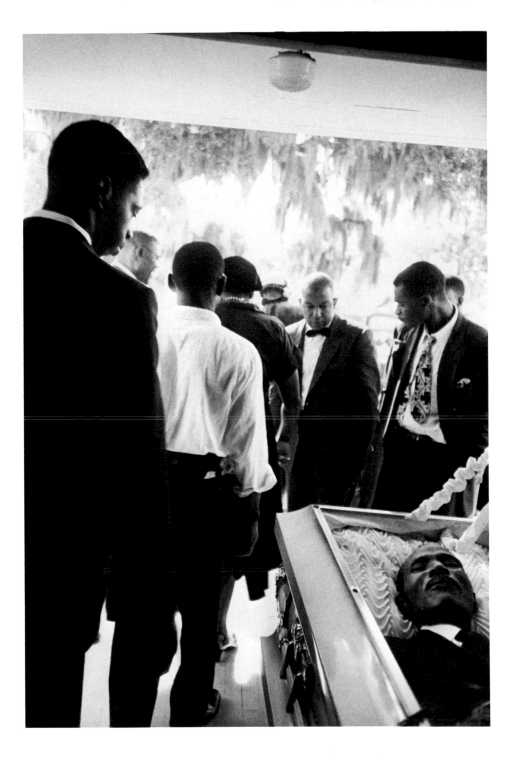

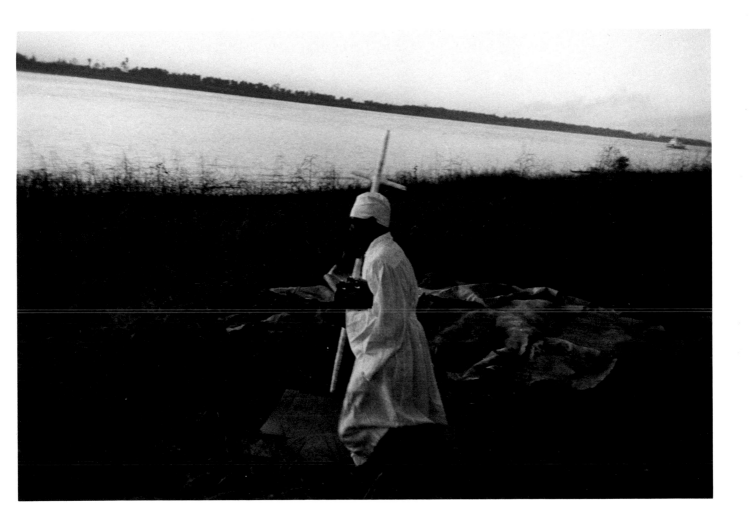

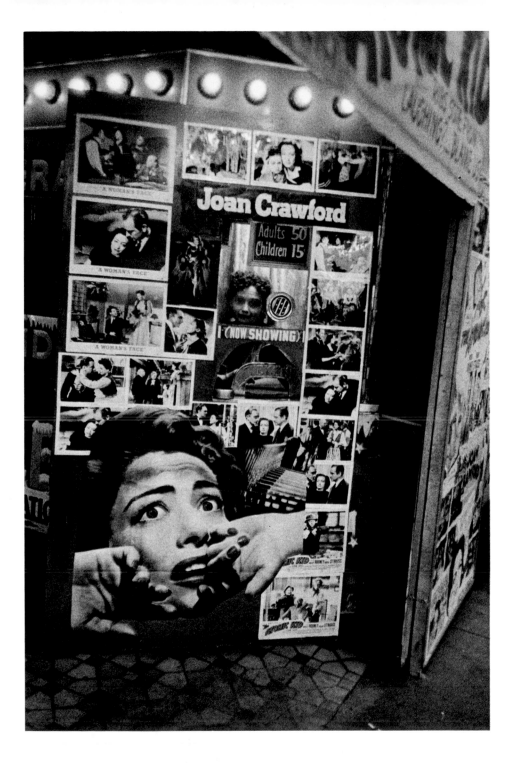

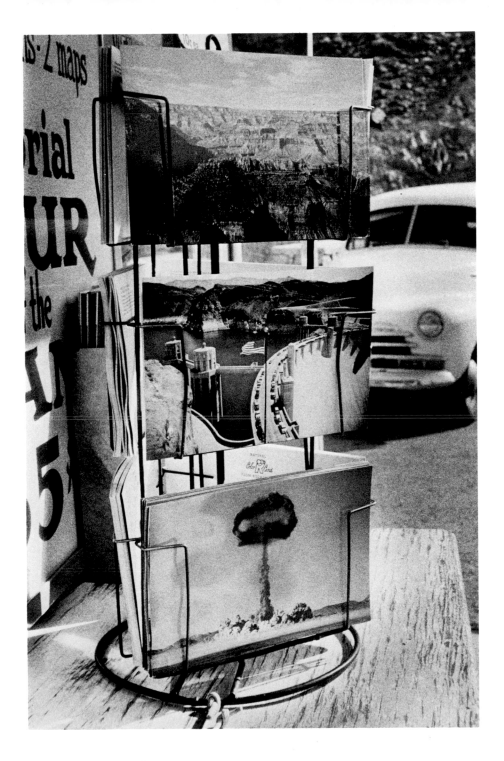

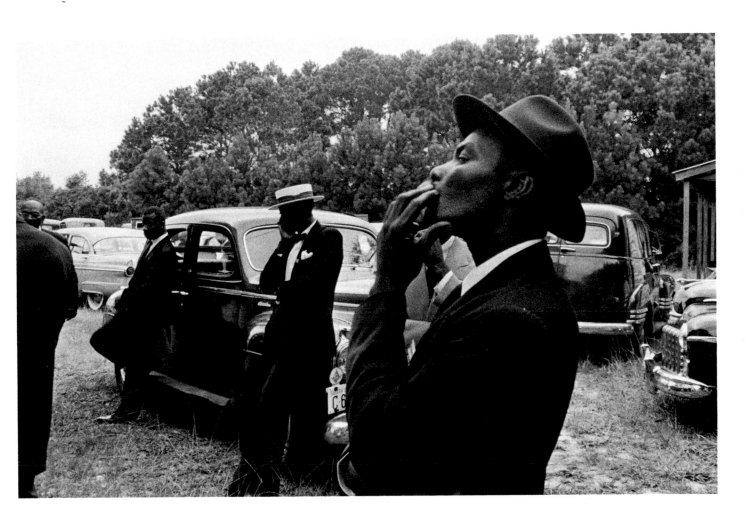

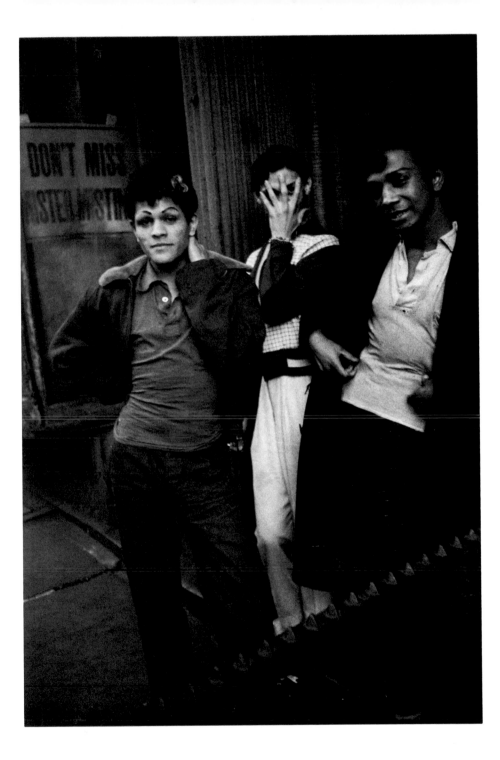

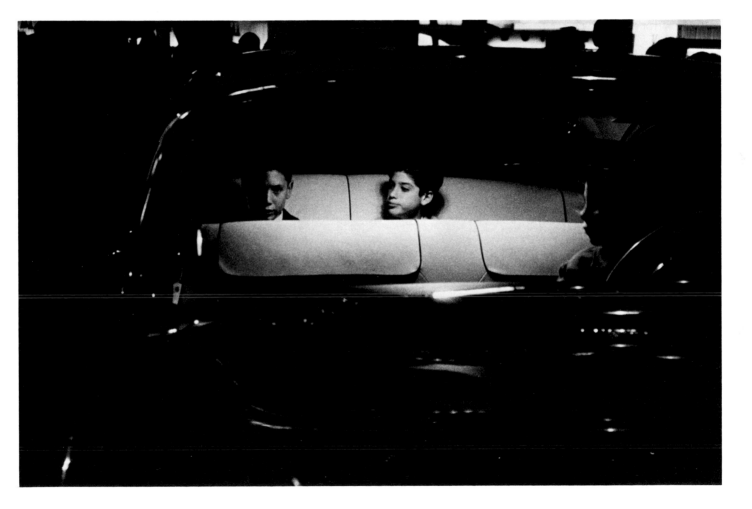

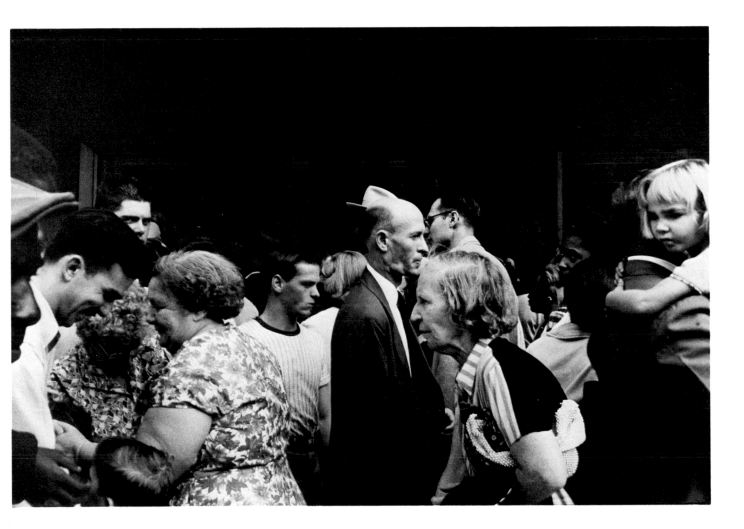

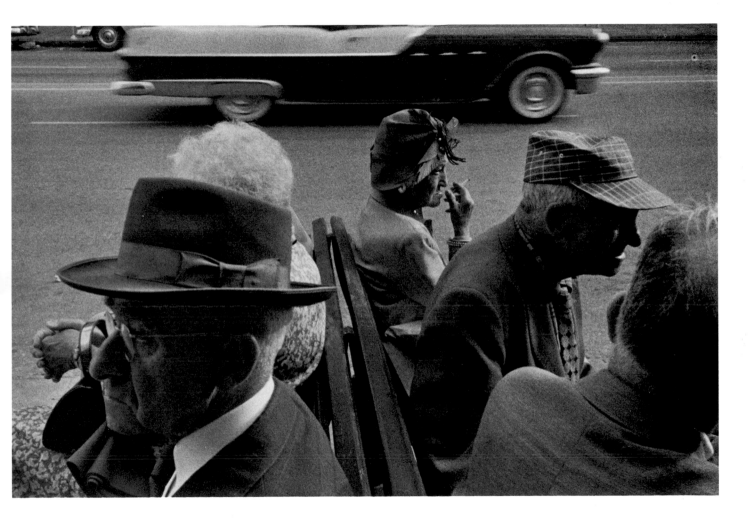

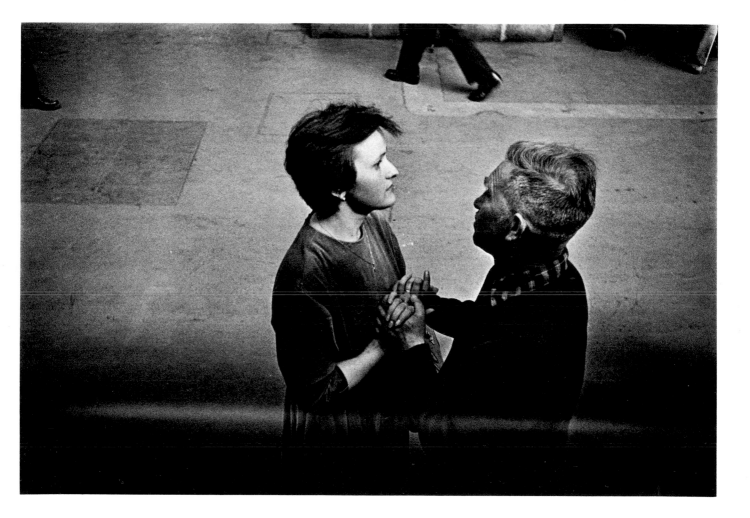

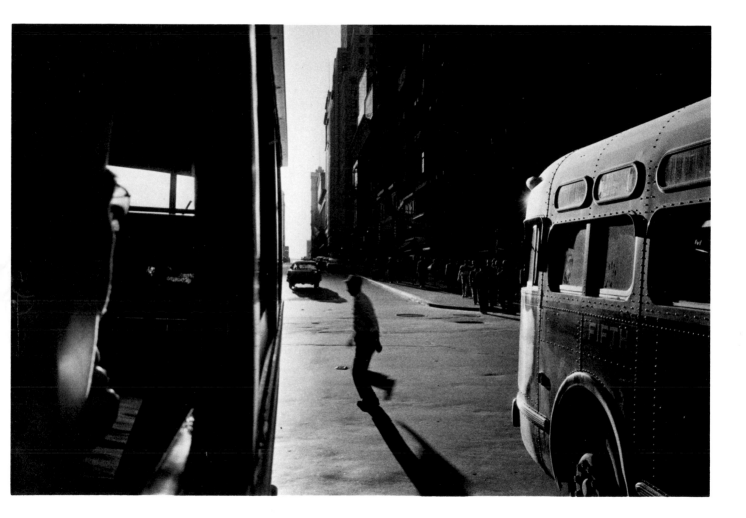

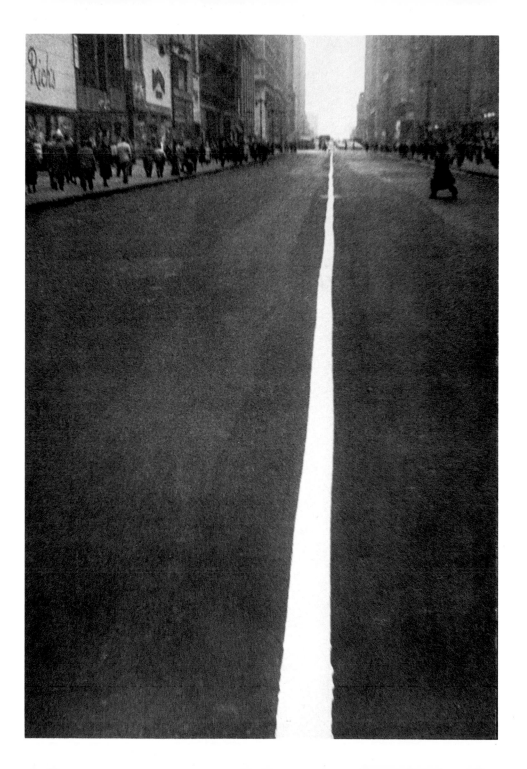

PHOTOGRAPHS

Front cover: Hoboken, New Jersey, 1955–56
Frontispiece: Chicago, 1955–56
7. Los Angeles, 1955–56
9. London, 1952
11. London, 1952
13. New York, 1951
15. Paris, 1949–50
17. New York, 1948
19. Paris, 1949–50
21. London, 1952
23. England, 1952
25. Wales, 1952
27. City Hall, Los Angeles, 1955–56
29. Hoboken, New Jersey, 1955–56
31. Chicago, 1955–56
33. East River, New York, 1955–56
35. Coney Island, 1958
37. Indianapolis, Indiana, 1955–56
39. Butte, Montana, 1955–56
41. New York, 1955–56
43. San Franciso, 1955–56
45. U.S. 91, Leaving Blackfoot, Idaho, 1955
47. U.S. 90, Texas, 1955–56
49. Peru, 1948
51. Valencia, Spain, 1951–52
53. Bunker Hill, Los Angeles, 1955–56
55. U.S. 66, Arizona, 1955–56
57. Gallup, New Mexico, 1955–56
59. Detroit, Michigan, 1955–56
61. San Francisco, 1955–56
63. Butte, Montana, 1955–56
65. Beaufort, South Carolina, 1955–56
67. St. Helena, South Carolina, 1955–56
69. Mississippi River, Louisiana, 1955–56
71. Detroit, Michigan, 1955–56
73. Hoover Dam, Nevada, 1955
75. St. Helena, South Carolina, 1955–56
77. New York, 1955–56
79. Los Angeles, 1955–56
81. New Orleans, 1955–56
83. St. Petersburg, Florida, 1955–56
85. Paris, 1958
87. New York, 1958
89. New York, 1948
95. New Orleans, 1955–56

CHRONOLOGY *by Robert Frank*

Grow up in Zurich—born in Zurich, November 9, 1924.

Become a Swiss in 1938(?).

1947. Go to America, forget about having become a zuriçois.

1950. Marry in New York. Mary is her name. Two children, Pablo & Andrea.

1955. Trip across the States, and Delpire publishes *Les Américains.*

Ich bin ein Amerikaner.

1960. Decide to put my camera in a closet. Enough of observing and hunting and capturing (sometimes) the essence of what is black or what is good and where is God.

I make films. Now I have to talk to the people who move across my viewfinder. It isn't easy nor particularly successful.

1969. Mary & I separate . . . Life dances on . . . June & I go to live at the end of a road in Nova Scotia. We build a building, overlooking the sea. I spend a lot of time looking out the window. Camera still in closet. I wait.

Andrea dies in airplane crash at Tikal in Guatemala, December 28, 1974.

1975. Have a job in California, teaching. June & I get married and we are back here, looking down to the frozen water. Isn't it wonderful to be alive . . . Making a film now, about a bunch of people living in shacks on an island, surviving barely, and the winter is coming. The lighthouse keeper alone on the top of the island is talking about the weather and how it used to be . . . My mother saved and put away the photos I sometime left behind. I want to thank her for believing in me when I was just beginning.

SELECTED BIBLIOGRAPHY

Indiens pas morts. Text by Georges Arnaud. Photographs by Wener Bischof, Robert Frank and Pierre Verger. Éditions Robert Delpire, Paris, 1956. American edition: *Incas to Indians.*

Les Américains. Photographs by Robert Frank. Text edited by Alain Bosquet. Robert Delpire Éditeur, Paris, 1958. American edition: *The Americans.* Introduction by Jack Kerouac. First edition, Grove Press, 1959. Revised, Aperture, Inc., New York.

Pull My Daisy. Photographs by Robert Frank. Text by Jack Kerouac. Grove Press, New York, 1961.

The Lines of My Hand. Text and photographs by Robert Frank. Lustrum Press, Los Angeles, 1972. Japanese edition: Kazuhiko Motomura, Tokyo, 1971.

EXHIBITIONS

1948. The Museum of Modern Art, New York. Five subsequent exhibitions.

1955. The Helmhaus, Zurich; the Art Institute, Chicago; the International Museum of Photography, Rochester.

1976. The Kunsthaus, Zurich.

FILMS BY ROBERT FRANK

1959. *Pull My Daisy.*

1961. *The Sin of Jesus.*

1963. *O.K. End Here.*

1965–68. *Me and My Brother.* A film about a silent man and an actor who becomes silent.

1969. *Conversation in Vermont.* A film about Pablo and Andrea.

Life Raft—Earth. A documentary.

1971. *About Me: A Musical Film About Life in New York City.*

1972. *Cocksucker Blues* (Rolling Stones).

1975. *Keep Busy.* In collaboration with Rudi Wurlitzer.

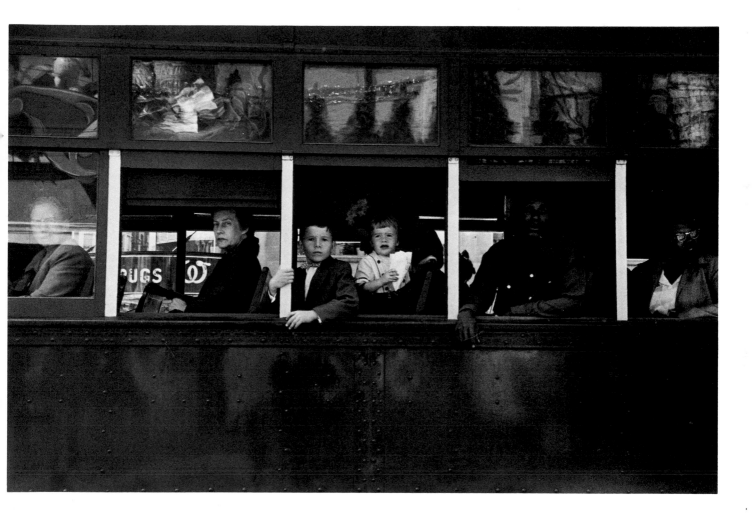